Angry Silence

Angry Silence

A collection of sublime and ridiculous reflections on life from poetry, observation and song.

by Ray Stone

Angry Silence

Copyright Ray Stone April 2019

All rights are reserved.

No part of this book may be used or reproduced in any manner whatsoever without the written permission of the author.

Formatting and Cover Design - Anthony Smits and Ray Stone

Acknowledgments

It is quite a task to choose material and design a book that presents one's poetry alongside meaningful photos that are part of each individual presentation.

Many thanks go to my friend and fellow writer-artist, Ant Gavin Smits, a wizard entrepreneur who helped design the layout and formatted this book. Ant, you are gifted, and I look forward to working with you on future publications. Thank you, my friend.

Sometimes it takes a while to realize how someone close is influencing your life, in particular with a little helpful moral boosting. Kimber Coleman, my late wife's friend, and carer has continued to support me through all the ups and downs of life. Her friendship has never been more important than it is now. Thank you, Kimber. You are wonderful.

Inspiration is a beautiful thing, especially when it comes from a group of fellow writers who one creates with. For eight years, I have been a part of a unique and exciting writing group of serial writers at The Story Mint, based in New Zealand. We support, help, and nurture each other. Thank you all for your support.

Last but just as important to me as anyone else. I have a wonderful friend and fellow writer who's advice and support has followed me across the world as I lived in the USA, then Malta and finally Cyprus. Dr. Delores Reagin, a noted author of distinction, has followed my career and read most of my work. To you, Delores, I say a special thank you with a quote you will love. Your advice and critique have been a great help in shaping my artistic career.

"Your battles inspired me – not the obvious material battles but those that were fought and won behind your forehead." ~ James Joyce

For
Kimber Lea Marie Coleman

Contents

The Smell of Smoke **11**
Trees are Alive **12**
Freedom's Symbol **15**
The Dream Park **16**
Neon City **18**
Tomorrow **22**
Waking Up **24**
Angry Silence **26**
Blues in Emerald City **31**

Sparrow, Starling, Woodpecker, Magpie **34**
The Rhythm Just Goes On and On **37**
No More a Lover **40**
Hold Me Close Tonight **42**
Ode To Blackie **45**
News from Eire **48**
Night-time Blues **52**
Midnight Train **54**

Seattle Christmas **57**
by Joseph Labrum
Guest Author

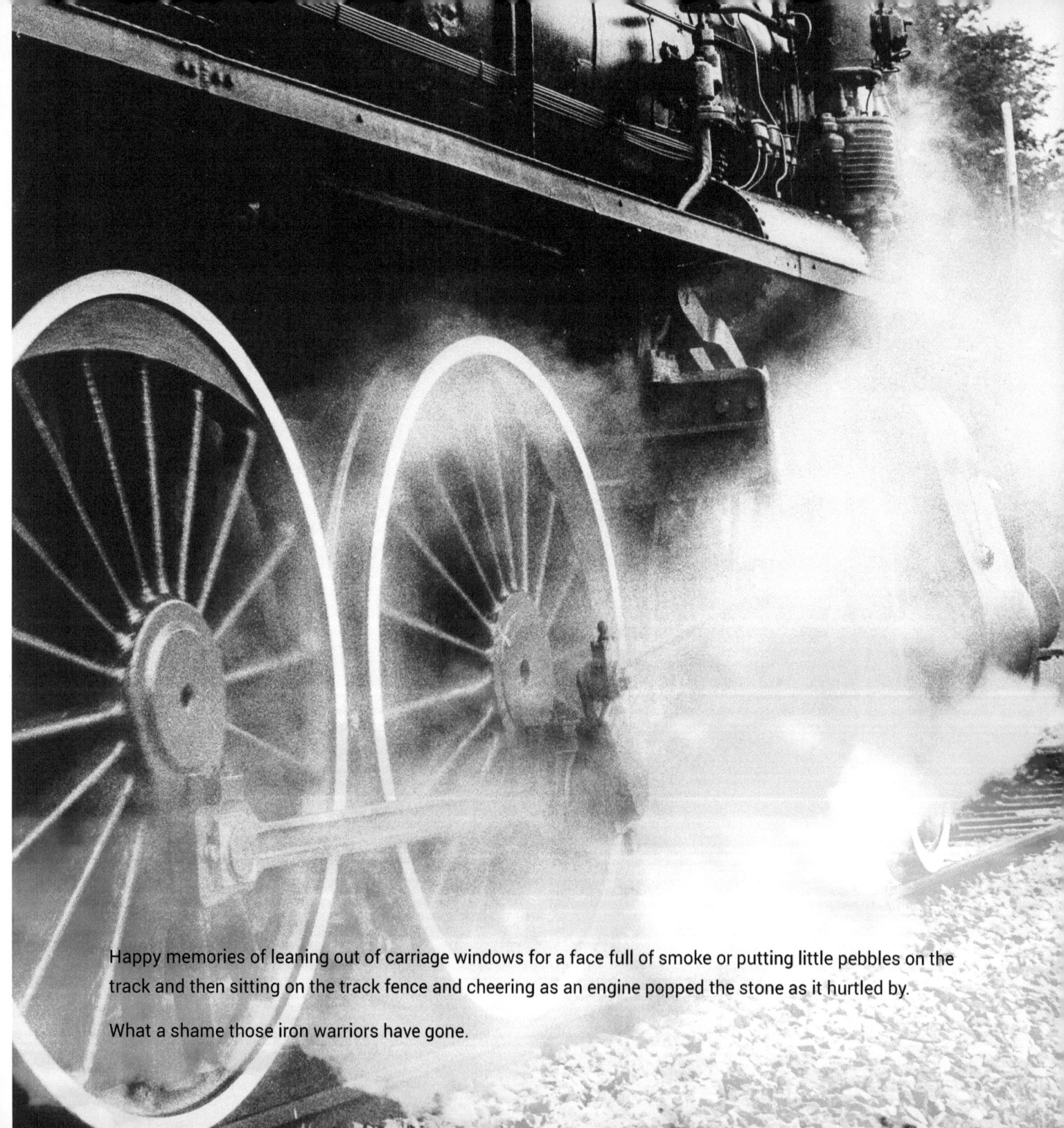

Happy memories of leaning out of carriage windows for a face full of smoke or putting little pebbles on the track and then sitting on the track fence and cheering as an engine popped the stone as it hurtled by.

What a shame those iron warriors have gone.

The Smell of Smoke

The smell of smoke, the loud hiss of steam
Images of a 2-6-4 hurtle through boyhood dream
Wheels clatter on points, the steam whistle blows
The fireman stokes furnace; drivers face all aglow
Trees beckon as countryside flashes from sight
Children playing, stop and scream with delight
So many memories of journeys by steam
Old man closes eyes and hugs boyhood dream

Where did they go, those Great Western trains
Each with its own particular name
There was Mallard, Scotsman, even Elaine
Stopping all stations or a fast through train
Spitting hot water and hissing with steam
Driver and fireman working hard as a team
Clickety-clacking along miles of line
Alas, they're no more, a great memory in time

Trees are Alive

Trees are alive, they filter our air
Don't chop them down, please have a care
Cedar, Ash, Willow, and Pine
Beautiful trees that have stood for all time
From each little acorn, there grows a tree
For our children, a legacy forever free

STOP POLLUTION NOW

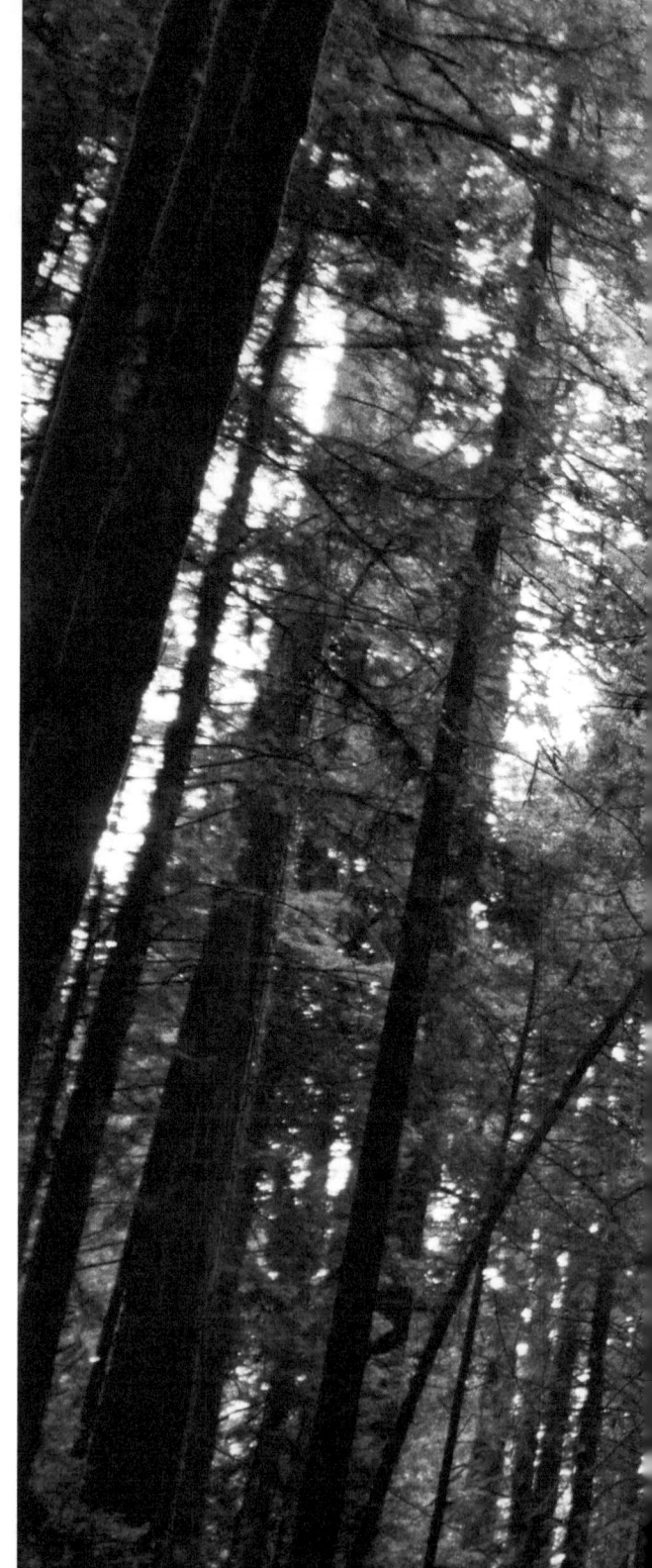

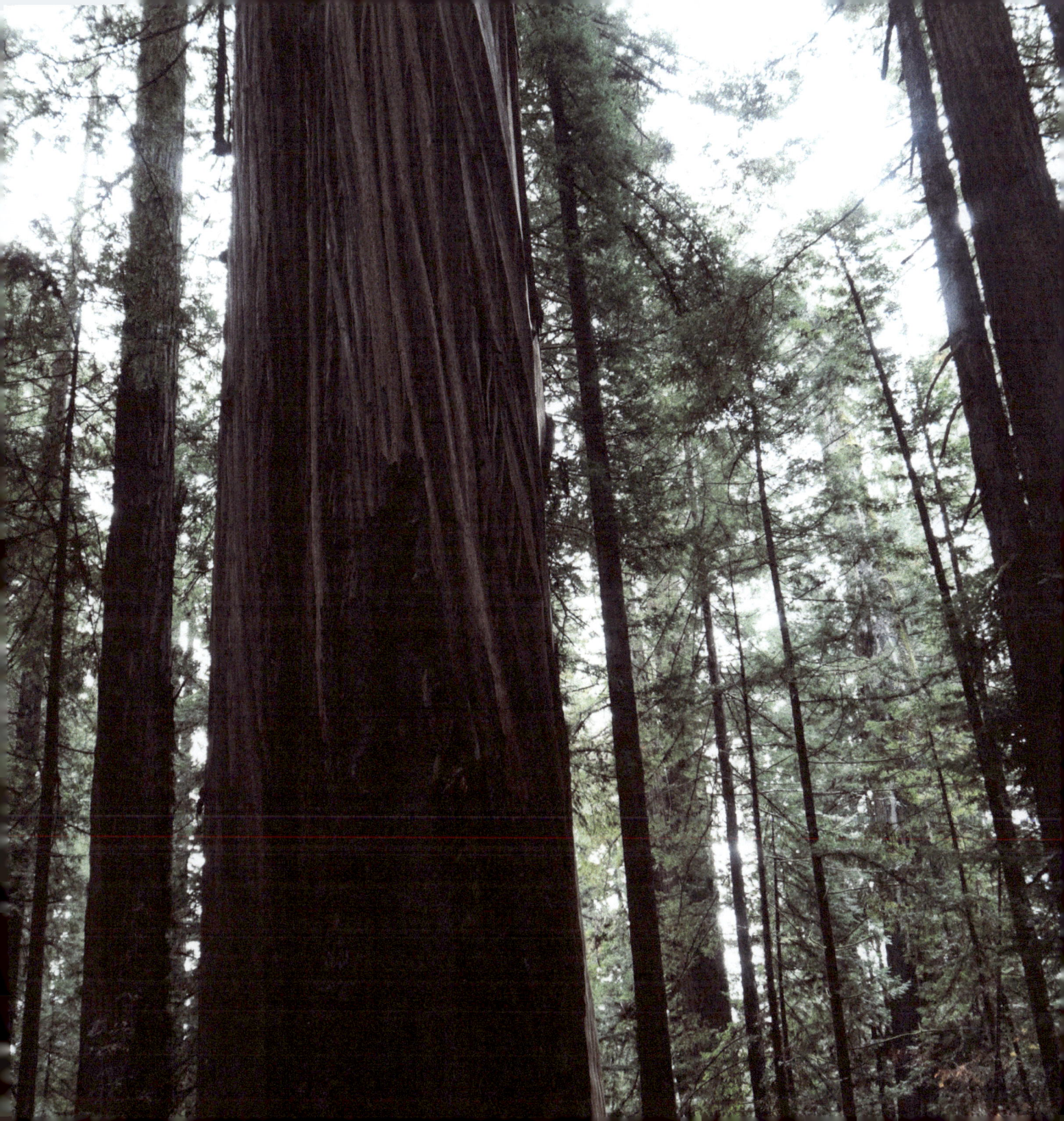

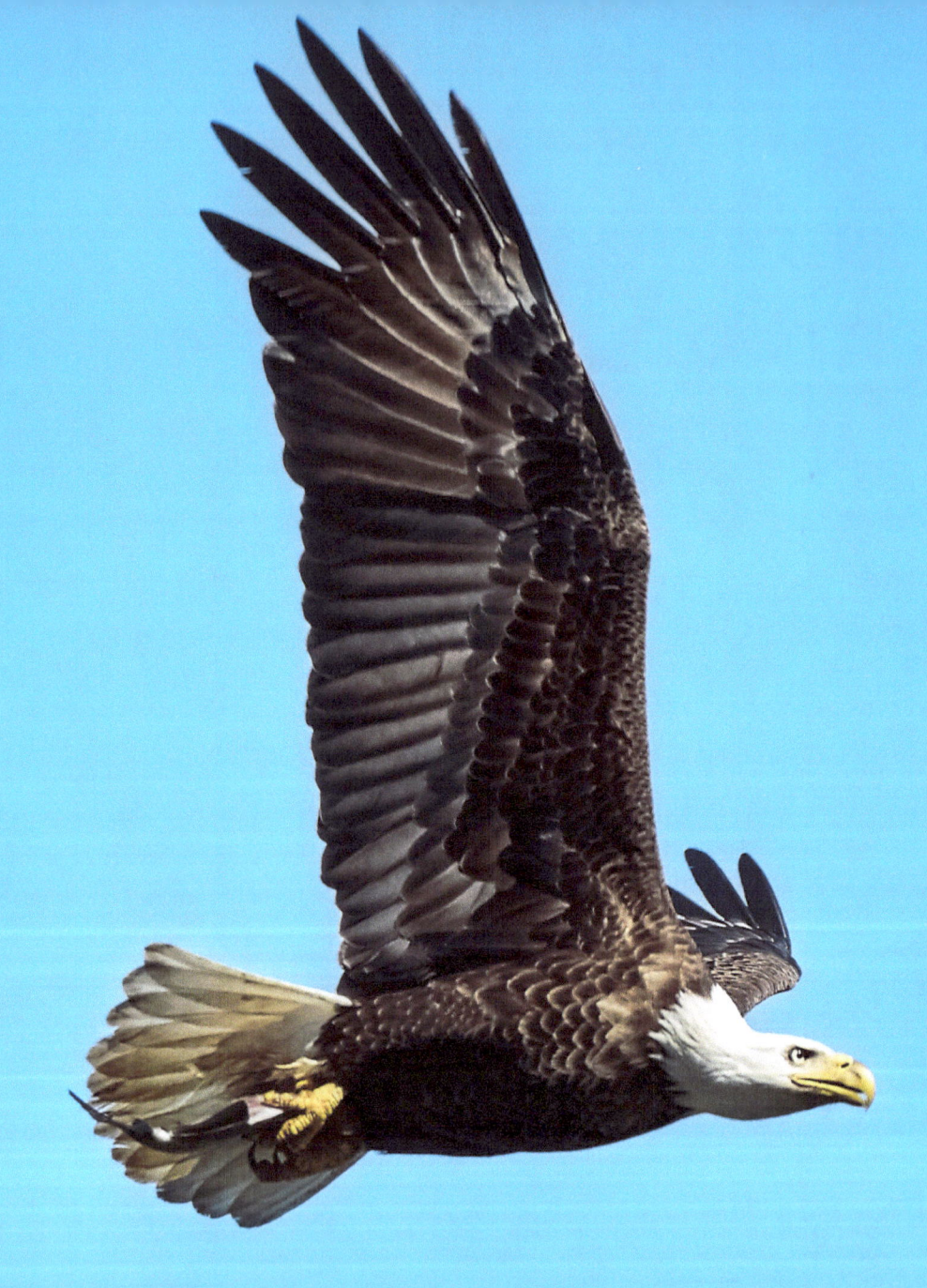

Freedom's Symbol

Glide on thermals over firs
Hide on perch in hemlock
Swoop on unsuspecting prey
Scoop and feast on craggy outcrop

Feed your fledglings, make them strong
Lead them into flight
Regal wings flap o'er the Sound
Eagle bald, breathtaking sight

Sometimes your breath is taken away when you observe something so beautiful that you've never seen before.

I saw my first eagle in Seabeck, Washington State.

The Dream Park

Around the park just one more time
follow the winding way
Images clear on mirrored lake
like golden memories, play
Willows swoop and bow their heads
as graceful swans glide by
Sunbeams pierce the leafy roof
while lovers stroll, and sigh

Seas of dark blue carpet
amongst the woodland vast
gently blown in tight unison
as squirrel scales a mast
Little dogs jump on falling leaves
roll on back and wriggle
Thrushes, Jays and Blackbirds sing
Lovers chase and giggle

Across the lake, beyond the hills
far across the windswept seas
The geese are landing in the Sound
carried there on autumns breeze
A figure walks along the shore
thinking of another,
happy thoughts and tears of joy
hoping for a lover

Ah yes, a year later I flew with the geese across Puget Sound and married that woman.

Neon City

Down in the depths of this living hell
a mass of writhing thighs
Flashing lights and glitter tights
No one wins a prize
Up on the street the men in black
are looking for some trouble
The face behind the counter smiles
blink once, he'll charge you double

Welcome to the Neon City
the music has just begun
Where coke and fear and cocktails
are all fused into one
Welcome to the Neon City
Fools dance in time to E
and addicts, pimps and losers
laugh and cry in harmony

There's a big blonde pouring out the drink
her fingers on the pulse
D.J's talking to himself
birthday bubbly's false
The noise is crashing off the walls
VIP's are getting high
The singer's playing her new track
There's stardust in her eyes

The man with no socks has just arrived
handshakes all round, Mr. Cool
Bongo's tapping out of time
Johnny calls him fool
Pied piper plays and still they come
Dance till he pulls the plug
Into the pit of hell they go
The music is like a drug

cont'd over

Into the night past the midnight hour
lights dance across the floor
Upstairs the drunks and riff-raff
stagger through the door
Music plays, it's getting louder
bleary eyes can't focus
Jack Daniels laughs, he's done his job
the city's full of jokers

Grays Thurrock on the River Thames, a port that is home to hard fighting dock workers and at one time, the sleaziest night club for dreamers, dropouts and drunks.

I enjoyed working there for three years.

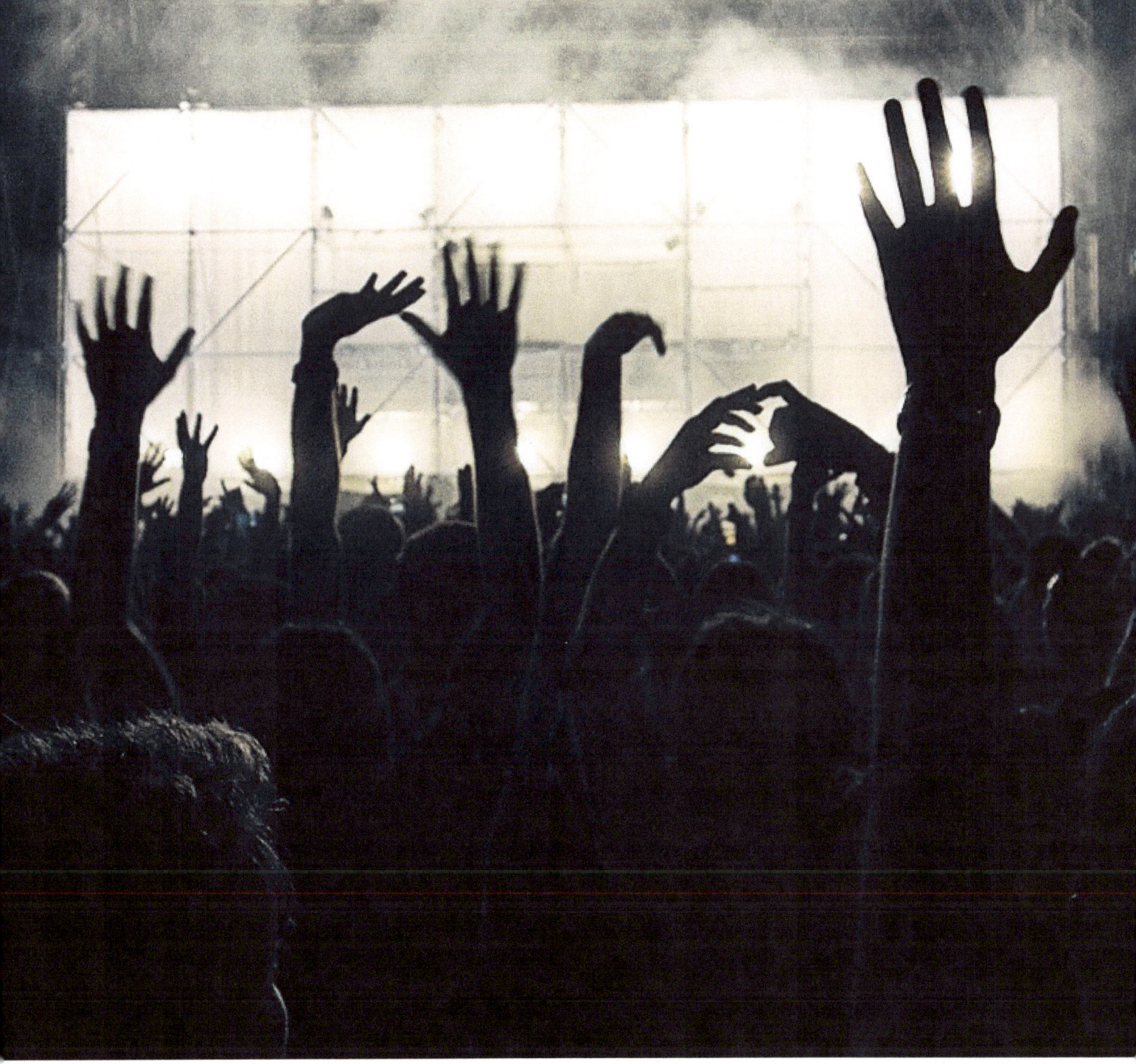

Tomorrow

Tomorrow is a life away
must I wait till then
Tomorrow sometimes never comes
for an authors pen
I close my eyes to see you
whenever I'm alone
I'm here for you my magic girl
my heart's your secret home

Ride around the universe
music fills the air
Find our rainbows end
climb the colored stair
Our love is getting stronger
the more we are apart
Waiting for the next time
kisses melt my heart

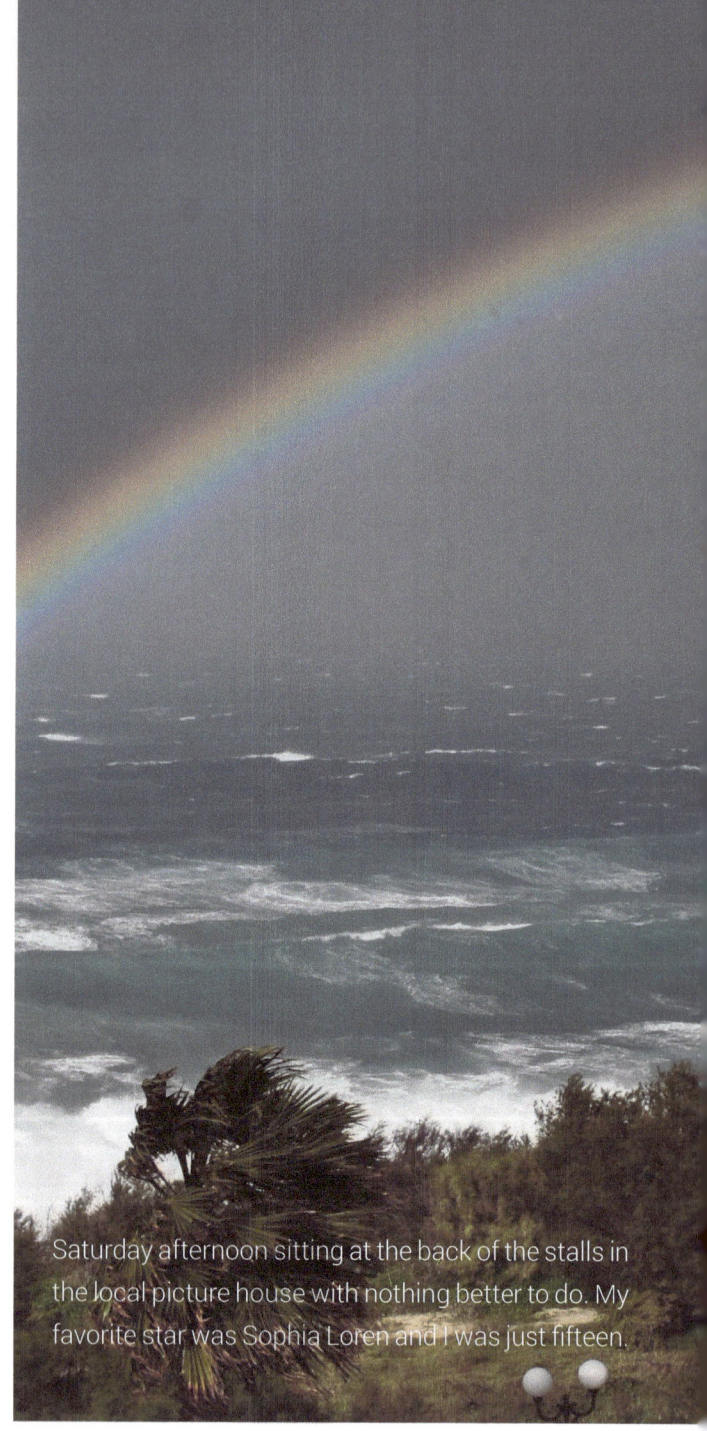

Saturday afternoon sitting at the back of the stalls in the local picture house with nothing better to do. My favorite star was Sophia Loren and I was just fifteen.

ANGRY SILENCE

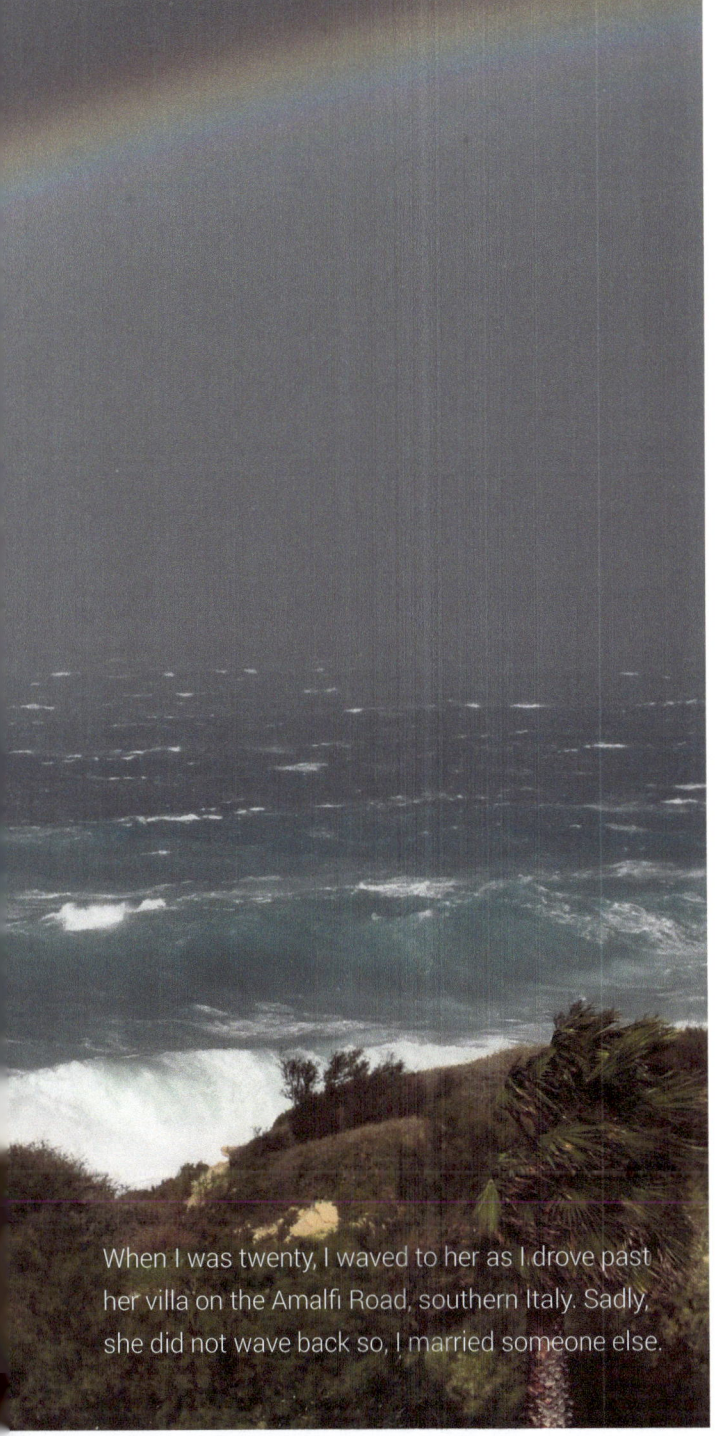

When I was twenty, I waved to her as I drove past her villa on the Amalfi Road, southern Italy. Sadly, she did not wave back so, I married someone else.

Sitting in the darkness
saying our goodbyes
Smile in close-up now
flash those sparkling eyes
From girl next door to lover
I've fallen for your charm
Waiting for that next dream
when beauty holds my arm

Feelings change in seconds
pulling us apart
Hold me closer now
the daydreams gonna start
There are so many others
but none love you as much
Goddess of the wide screen
I'm yearning for your touch

Waking Up

Stones are jumping like Jack Flash
Miss Yoko stayed in bed
Maddy acted like a virgin
Elvis P's not dead

Who's that girlie, stand by me
brown sugar rocked the blues
Heart B motel's got everything
Even blue suede shoes

Hard day's night was yesterday
Mick's getting off his cloud
They're still listening to Madonna
Elvis would be proud

Waking up is hard to do
My dream's full of the best
I'm gonna put the coffee on
And let Madonna dress

There were many mornings like this in the seventies.
I think the weed was a little too strong.

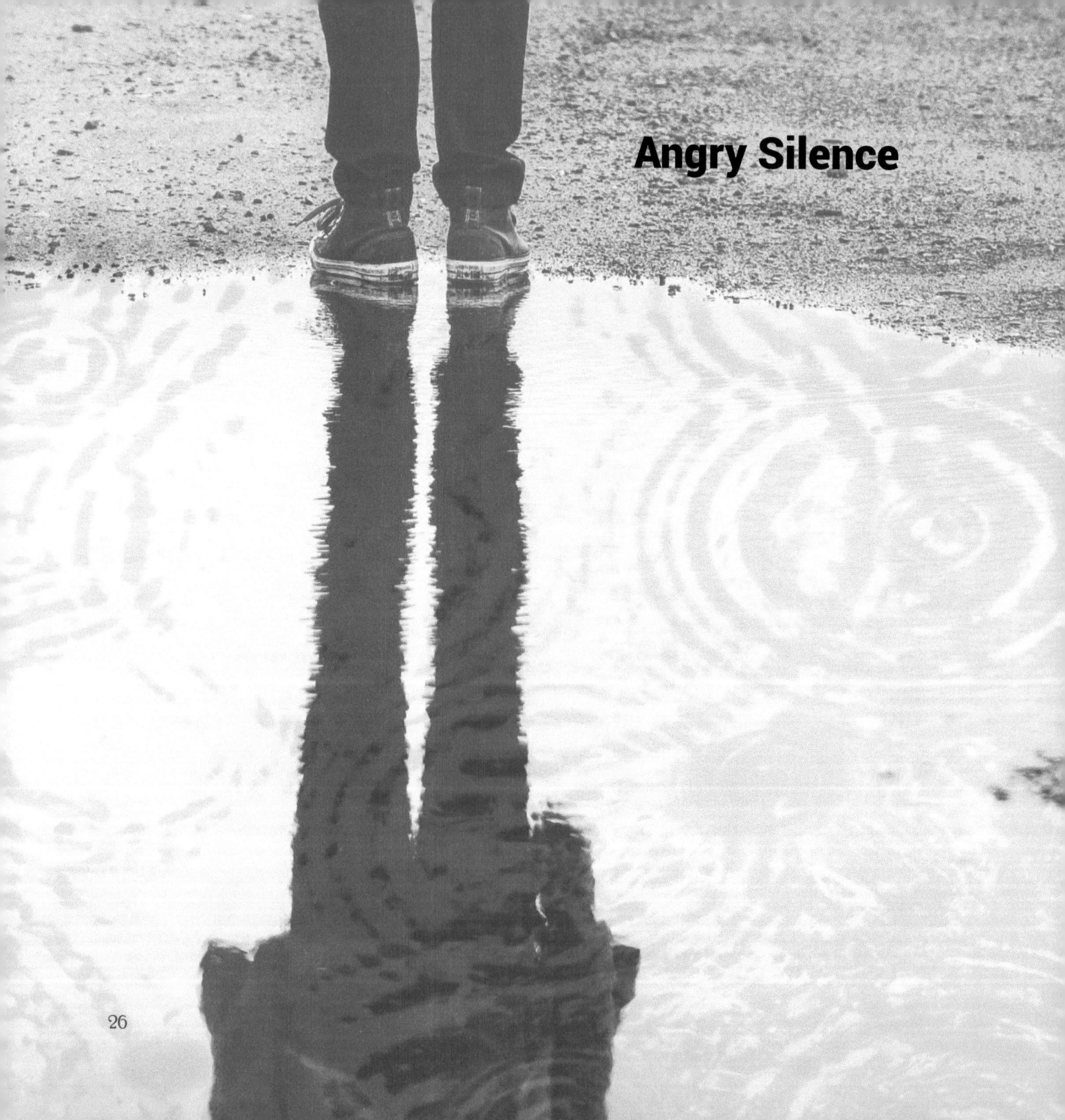

Erix Publications International
Winner: **Poem of the Month**, March 1998

There's a cold wind blowing
through cardboard city tonight
Huddled bodies in street doorways
hide from flickering lights
The rain pours down on moving homes
each one is filled with violence
No one wants to know their plight
there's just an angry silence

Bright lights have lost their attraction
in a child's life just begun
A runaway from his mother
no longer called her son
Cigarettes and cups of coffee
standing on red light streets
a sad and lonely figure
the office types he greets

cont'd over

ANGRY SILENCE

Little packets bought in shadows
will release him from his hell
The world will see his other face
what stories he can tell
Saturday night, the money's good
the city center lives
It breathes and breeds the poison
that's left his life in shreds

In the early hours of morning
while body hides from storm
he thinks of all the wasted years
of home, and love, and warmth
Through tears and sorrow, all alone
to live now makes no sense
In darkest hour there's nothing
Just an angry silence

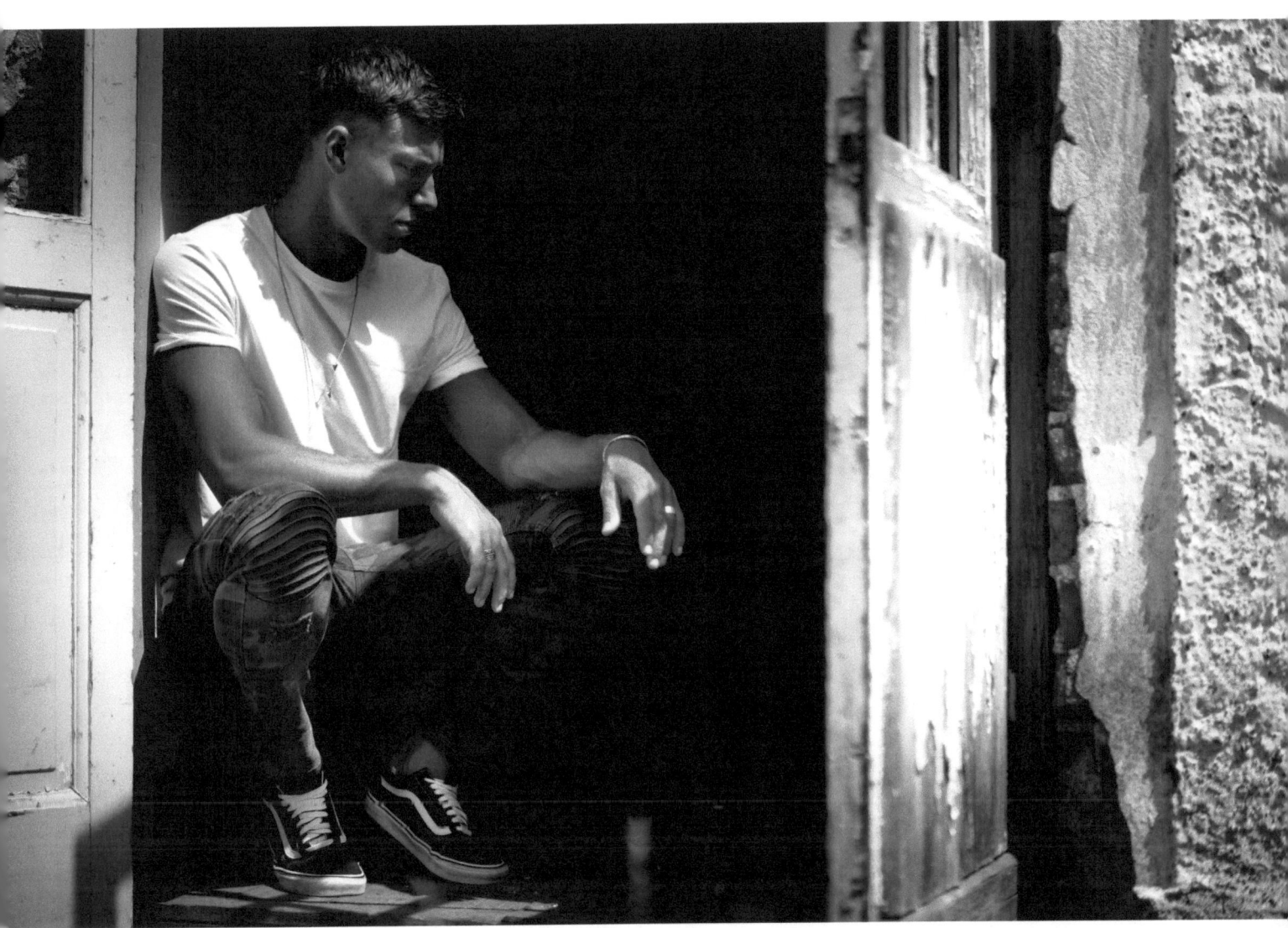

A sad dark side to London Town that hides behind all that glitters. Meths drinkers, addicts and young prostitutes living their miserable existence yards from an indifferent public.

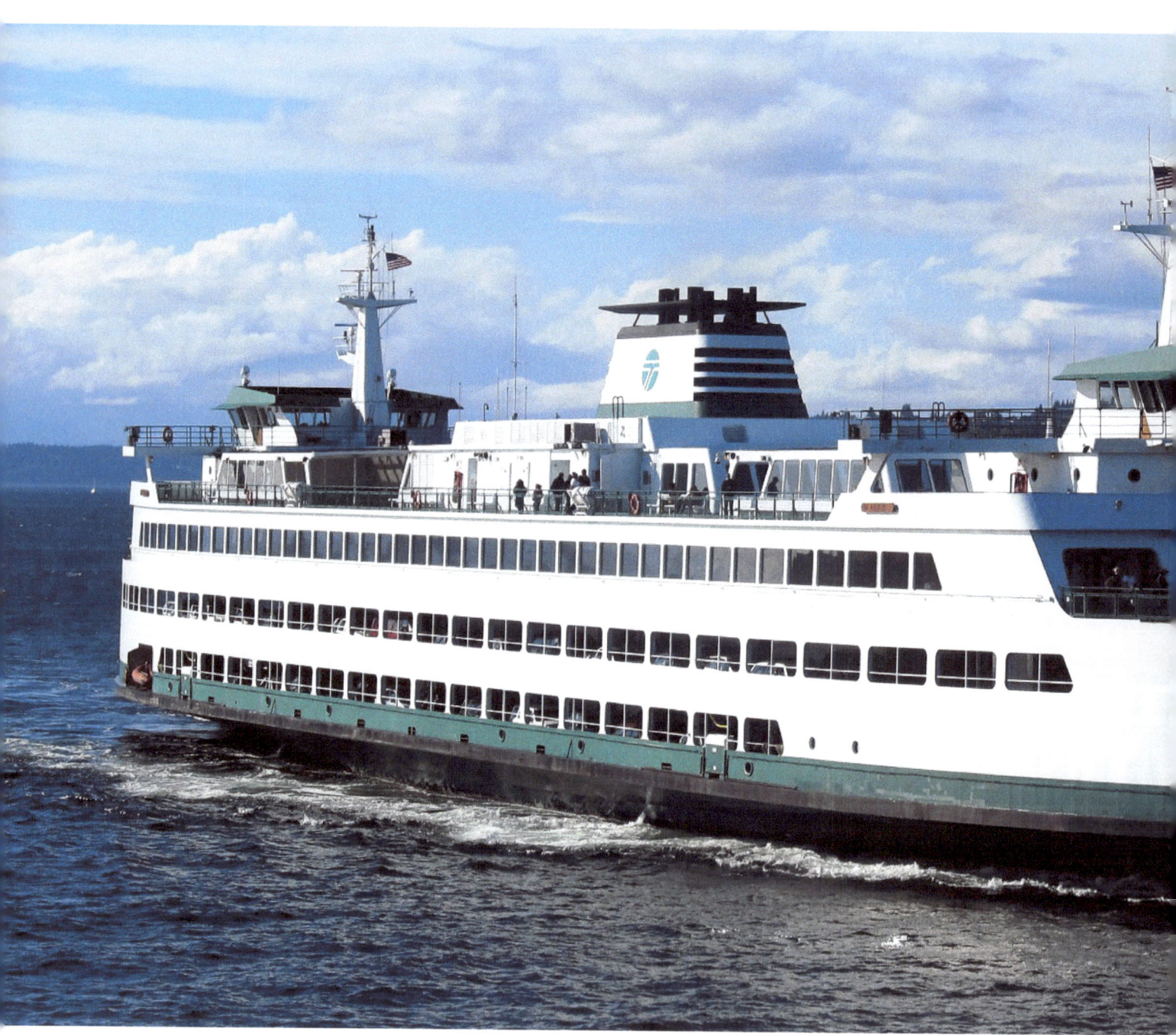

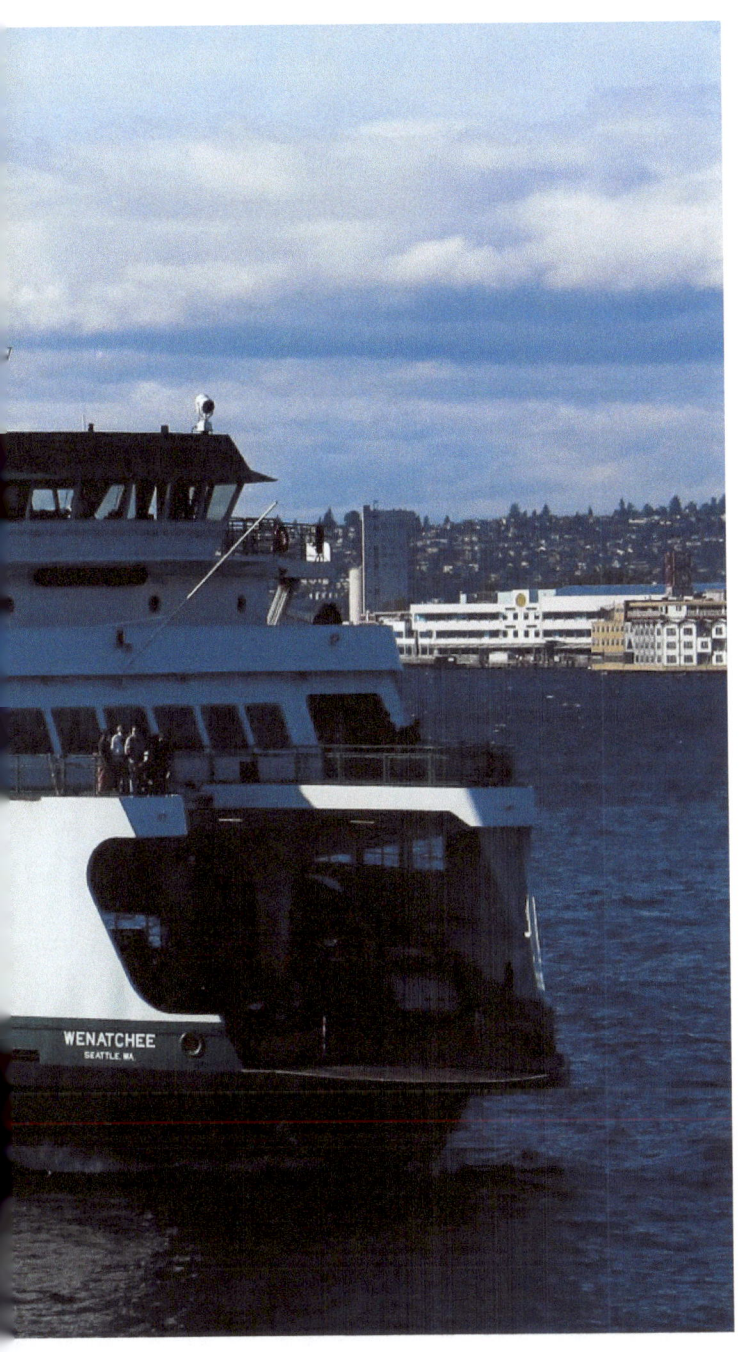

Blues in Emerald City

I'm waitin for the ferry
Yeah, lookin cross the Sound
My sweet baby's left me all alone
she was big dream city bound
Somewhere in a crowd of troubled souls
she'll be hangin round the square
the square that shows no pity
Only dream my woman has
Is Blues in Emerald City

cont'd over

There's a heartache on the ferry
oh, no one knows my pain
I'll keep walkin till I find her
walkin through the tears and rain
Hammerin man on first avenue
he's not sayin where she's at
he hammers without pity
Iron giant without soul
There's Blues in Emerald City

A poor man stands in Pike Place
He's holdin out his hand
In his empty eyes I see her
earnin booze with one night stands
Somewhere on these blacktop slopes
gonna find her in a bar
the bar that keeps ya dizzy
Red eyed singer sings the blues
Sings Blues in Emerald City

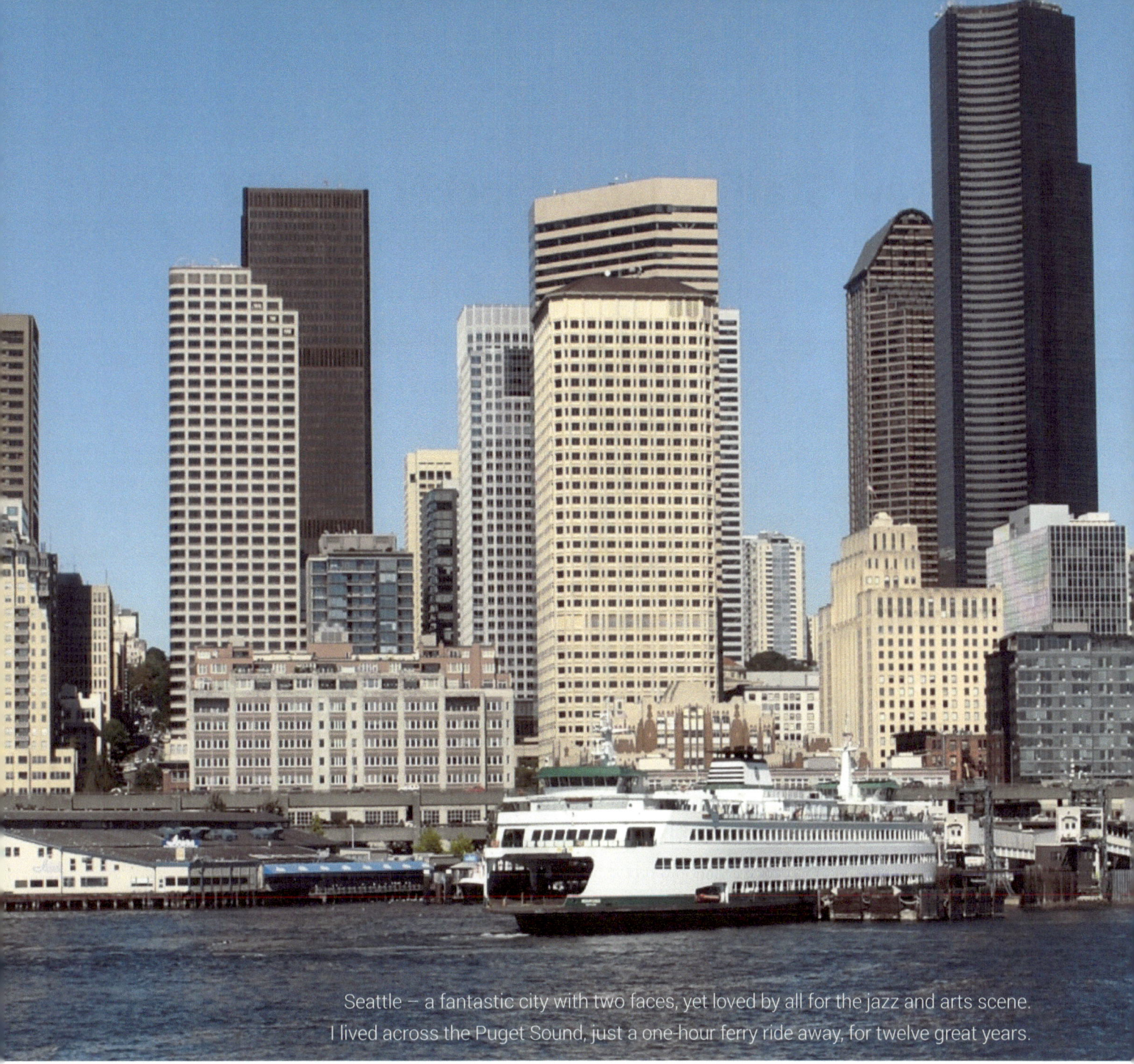
Seattle – a fantastic city with two faces, yet loved by all for the jazz and arts scene.
I lived across the Puget Sound, just a one-hour ferry ride away, for twelve great years.

Sparrow, Starling, Woodpecker, Magpie

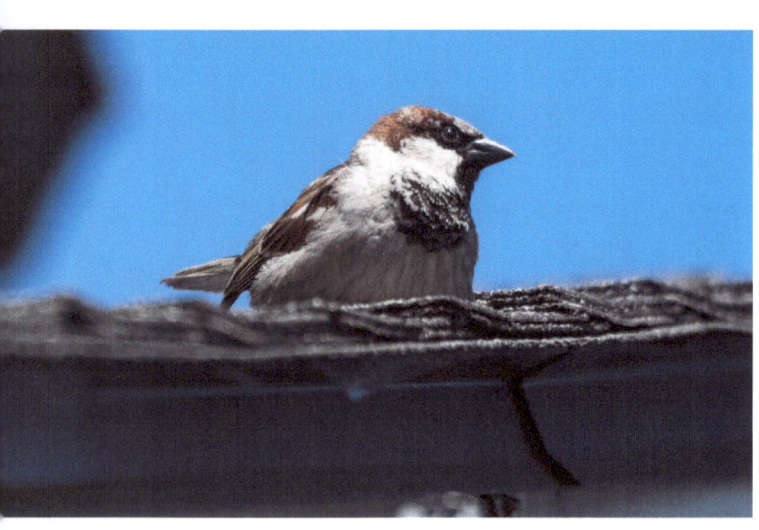

Down you come to join the rest
squabble over feeding
Never less than half a dozen
just like a mothers meeting
Squawking, screeching, running round
you're quite a noisy bird
Don't give up your day job,
your song's the worst I've heard

Hey little chap, cut the noise
I'm trying to get some sleep
Don't you know what time it is?
I can hear your dancing feet
Join your mates down in the garden
don't get in a flutter
Give me just another hour
Get off my bloody gutter

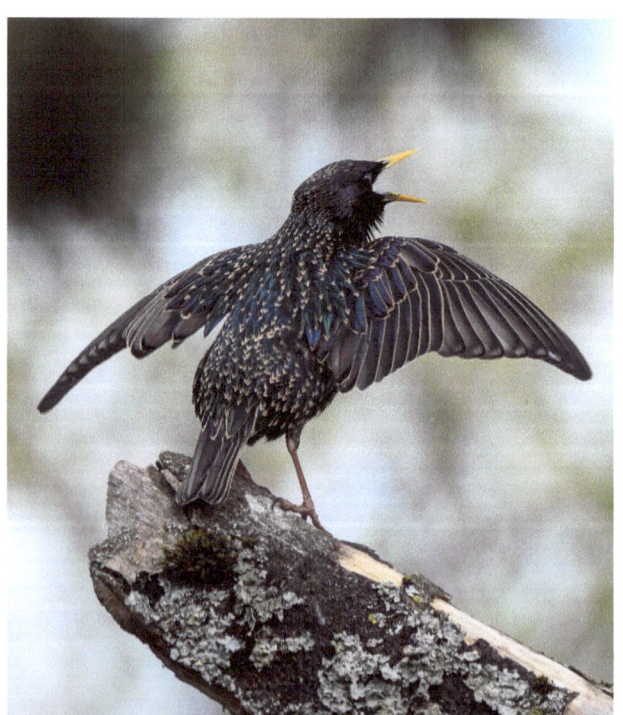

ANGRY SILENCE

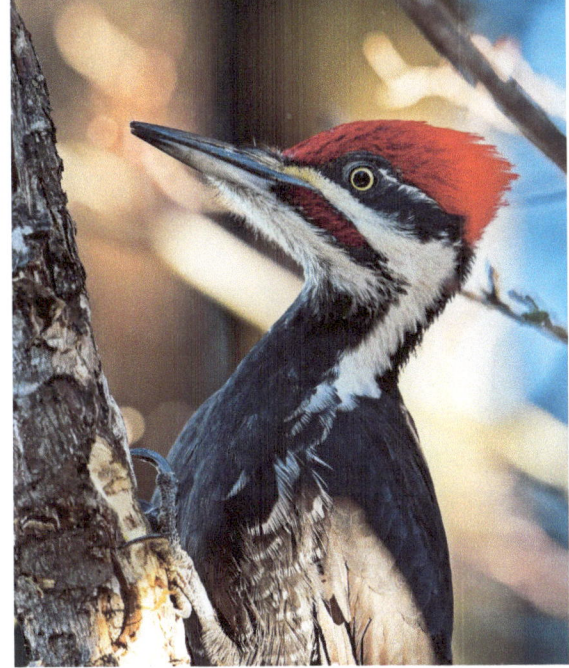

Shiny silver, golden rings
you've caused a lot of grief
Don't look through my window,
lovable feathered thief
With head bowed low and sparkling eyes
all black and white and coy
you don't fool me you saucy rogue
you naughty little boy

I can hear you but cannot see you
you're pecking high in Birch
You're very busy during Spring
standing on your perch
You can't stay in my woods
some think you woodland wrecker
Take care my little feathered friend
Don't lose your little pecker

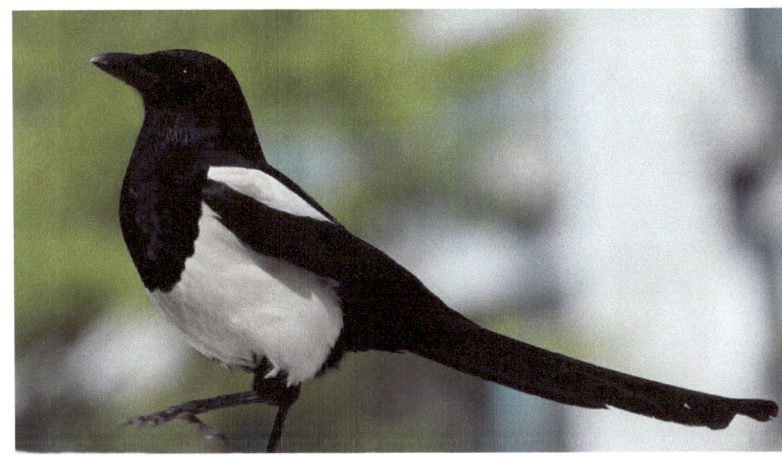

I used to love birds until a pigeon dropped a large portion down my neck while I was window shopping at Tony the Greek's naughty entertainment emporium in Soho, London.

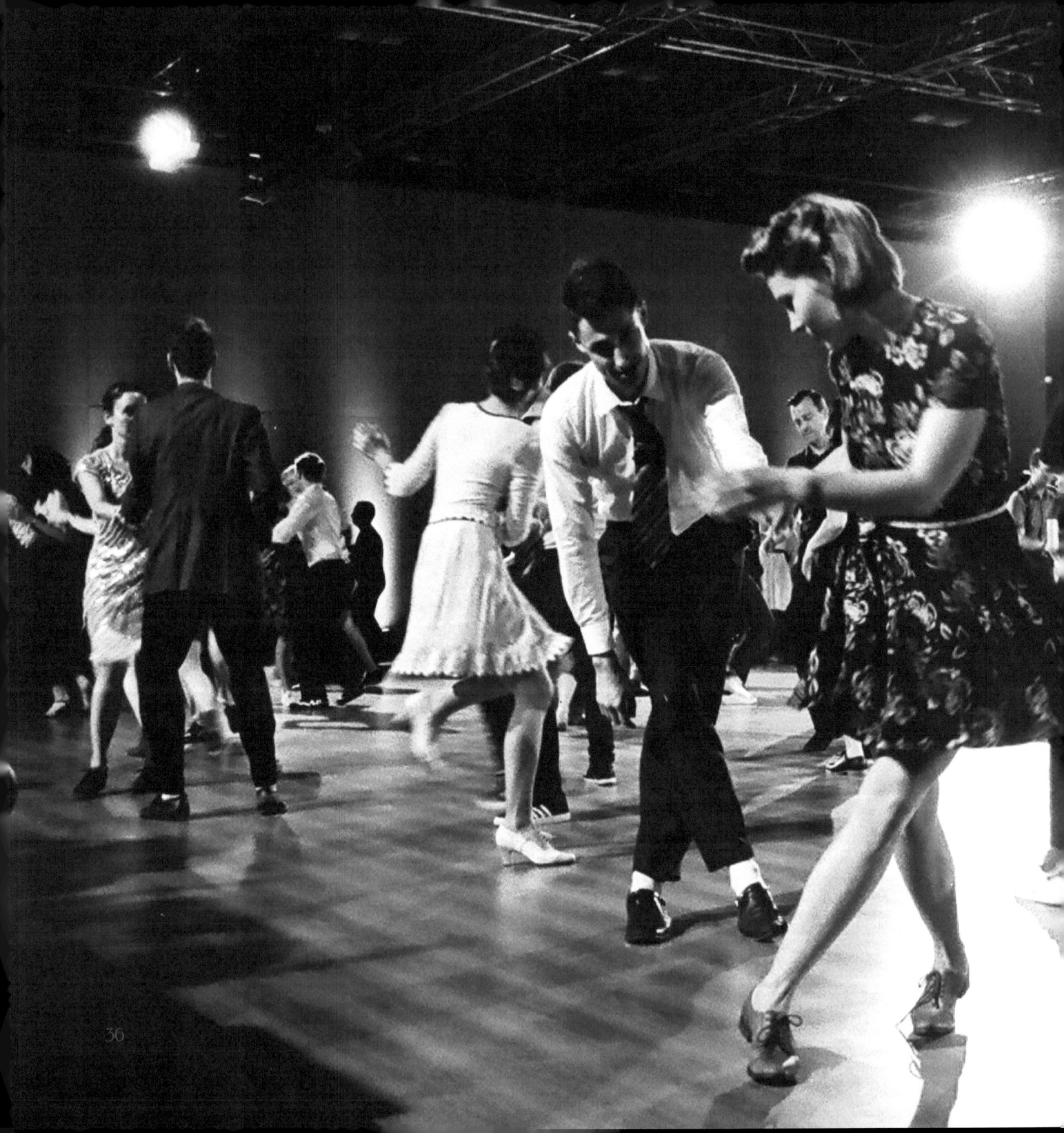

The Rhythm Just Goes On and On

Dancing bodies cross the floor
stay with me tonight
Come let's dance our secret dance
I'll make you feel alright
Touch me here, touch me there
Let the Lambada start
Give a little, take a little
Open up your heart

The rhythm just goes on and on
lights flashing all around
The dance we dance goes on and on
our footsteps make no sound
The beat is pounding in my head
this love is so complete
Around we go as one again
like shadows when they meet

cont'd over

Put your body next to mine
hear the rhythm pound
caress me with your fingertips
don't make another sound
Kiss me here, kiss me there
please whisper in my ear
Shake a little, sway a little
tell me that you care

Bodies locked in sweet embrace
tears flow down your cheek
Loves moves will soon be over now
as dance turns into sleep
Hold me here, hold me there
let's slow the pace right down
Smile a little, cry a little
rest for loves next round

First time is the best time, never to be repeated. What a shame. Mind you, as we get older, what used to take two minutes now takes half an hour and that can't be too bad, can it?

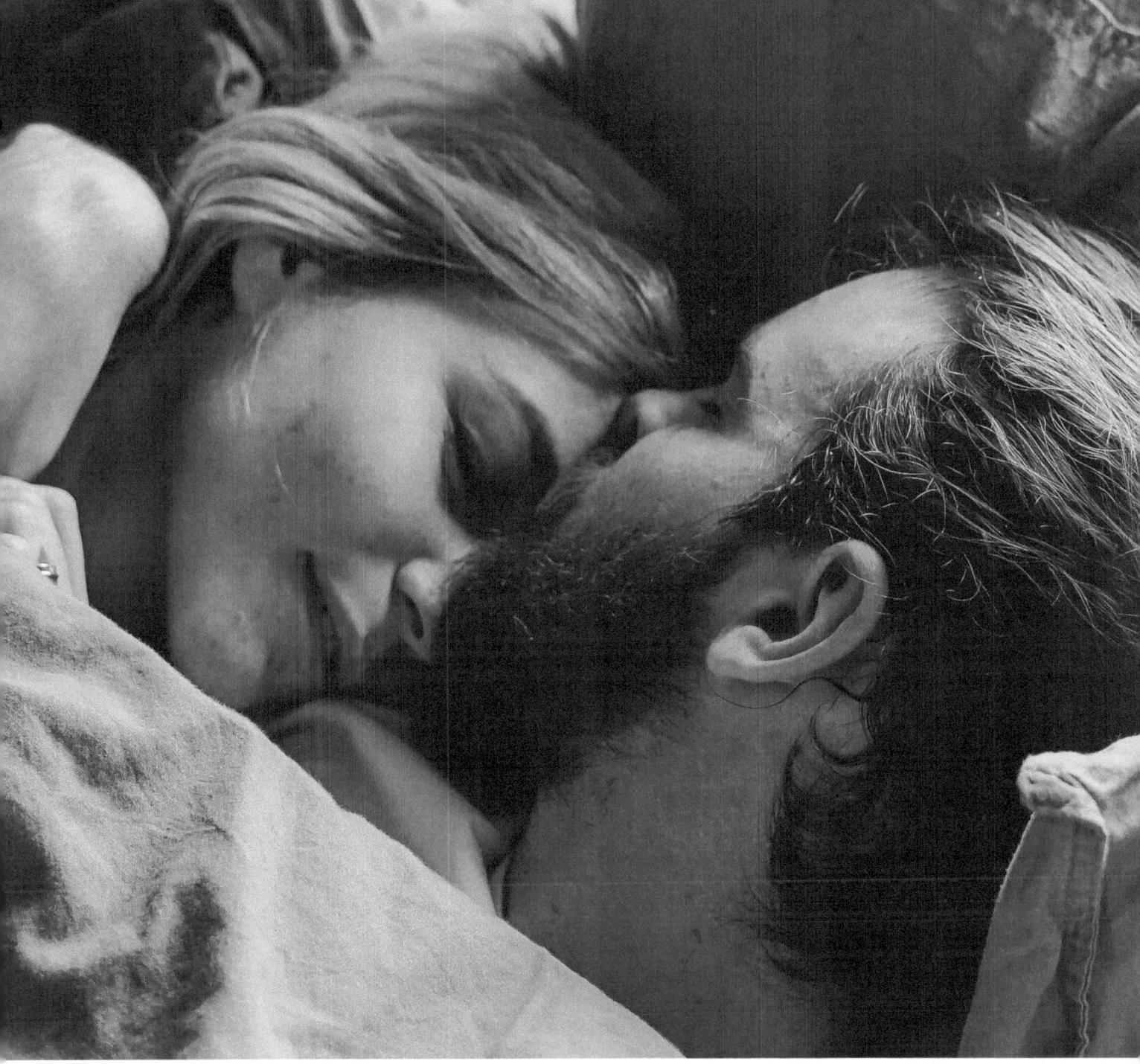

No More a Lover

This is our life as we grow apart
no one knows who is breaking whose heart
We had moments of passion, our secrets untold
all are now locked in a heart that's turned cold
My mind is now filled with empty spaces
gone are those pictures of sweet smiling faces
Stored in my memory, covered in dust
love lays dormant, shattered by trust

Strong arms encircling, tear stained face
both are locked in exhausted embrace
Hands hold each other, afraid to let go
whilst feelings of ecstasy ebb and flow
Two pairs of eyes search into each other
gone is passion, gone the lover
Why did this bond get torn apart
together alone, two broken hearts

The time has come, we cannot go on
the years have passed, the days are so long
Champagne and roses, pretenses, nights out
no point in kicking loves embers about
We go through the motions of life together
the love we knew is lost forever
No reason left to suffer this pain
no words are spoken, no need to explain

Feelings and reflections
during a period of depression
that I suffered shortly after parting
with my second love

Hold Me Close Tonight

Kiss me, let me touch your lips
I'm in heaven when you smile
Look at me with loves bright eyes
Stay with me a while

Hold me tightly in your arms
Run fingers through my hair
Please my love, don't leave me
Show me that you care

Please don't leave me all alone
Life's light is burning bright
Lay your body next to mine
Hold me close tonight

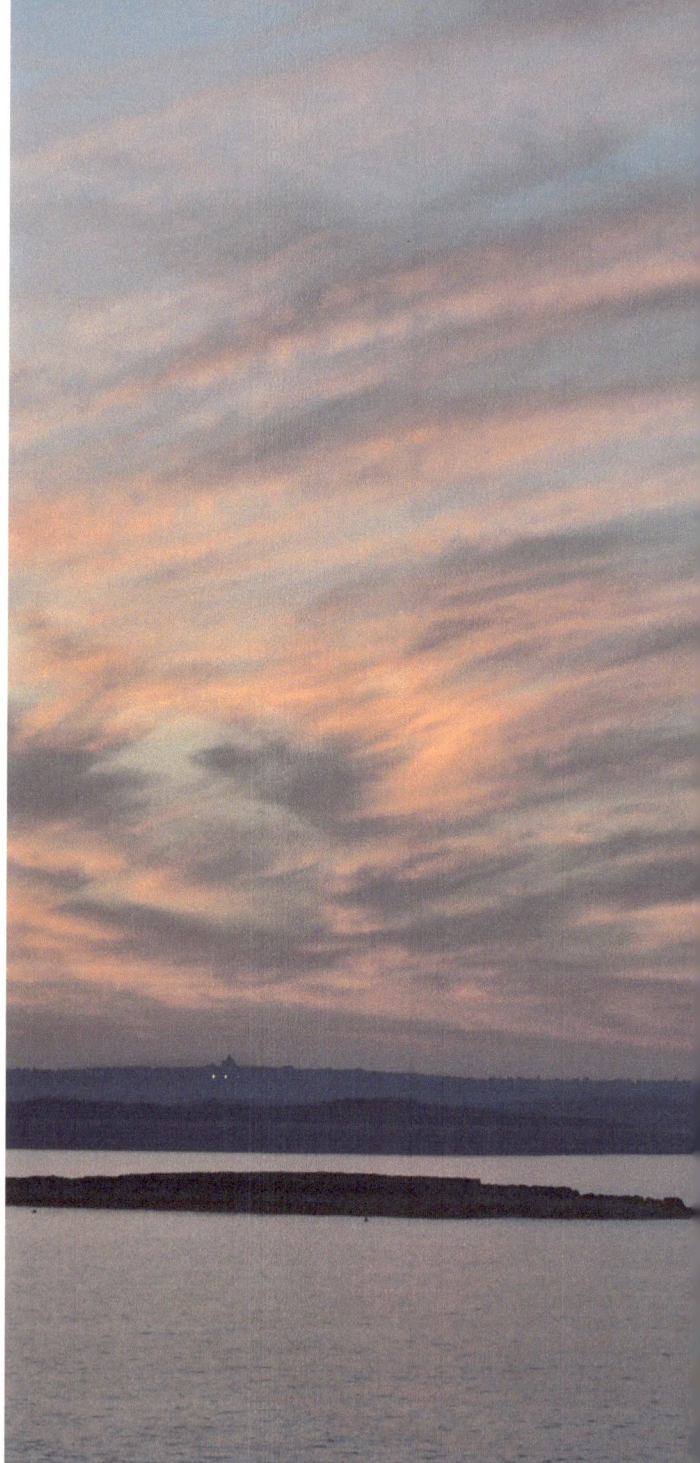

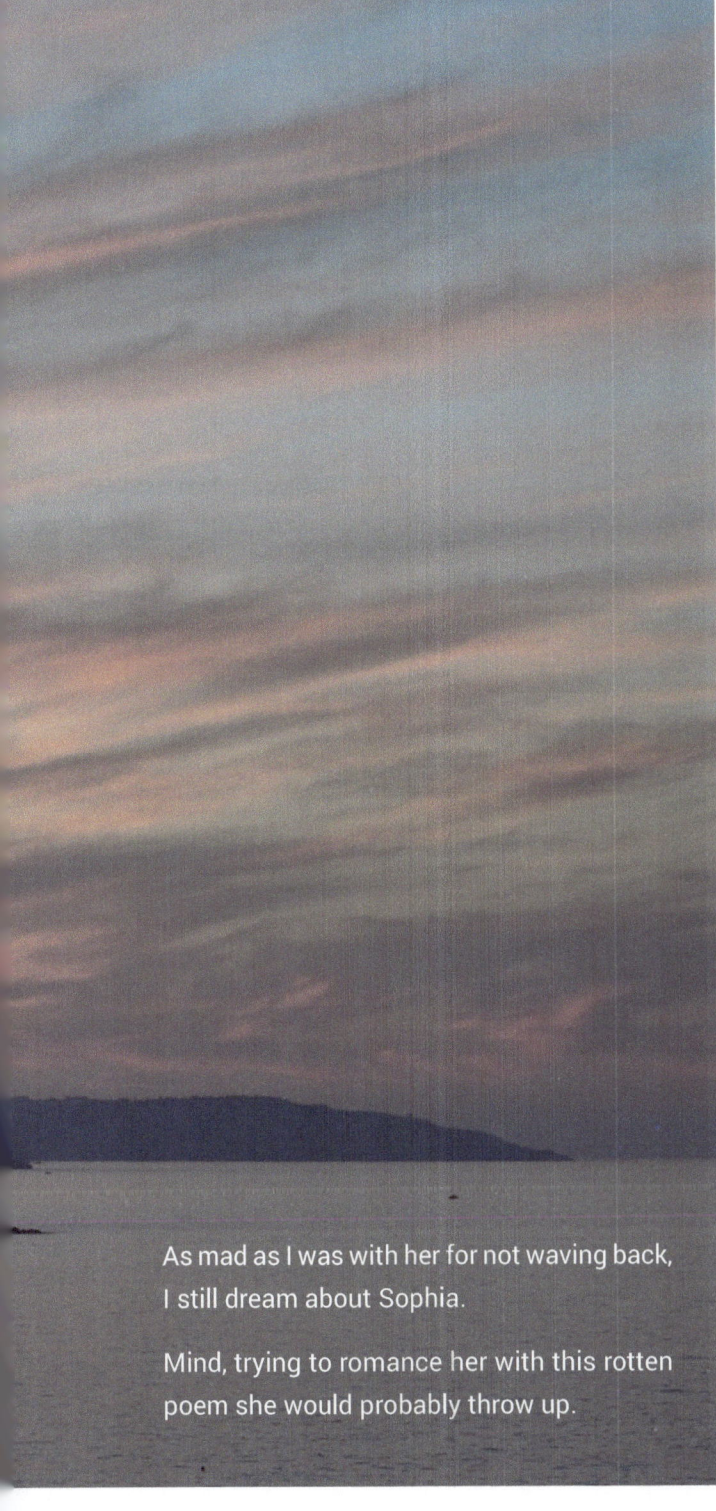

As mad as I was with her for not waving back, I still dream about Sophia.

Mind, trying to romance her with this rotten poem she would probably throw up.

Touch me with your fingertips
Let your heartbeat show you're mine
Why spoil these feelings we're enjoying
Love is endless, so is time

Come a little closer babe
Wrap your body in my love
I need your warmth to see me through
Sweet words are not enough

Please don't leave me all alone
Live while the light is bright
See the darkness through together
Hold me close tonight

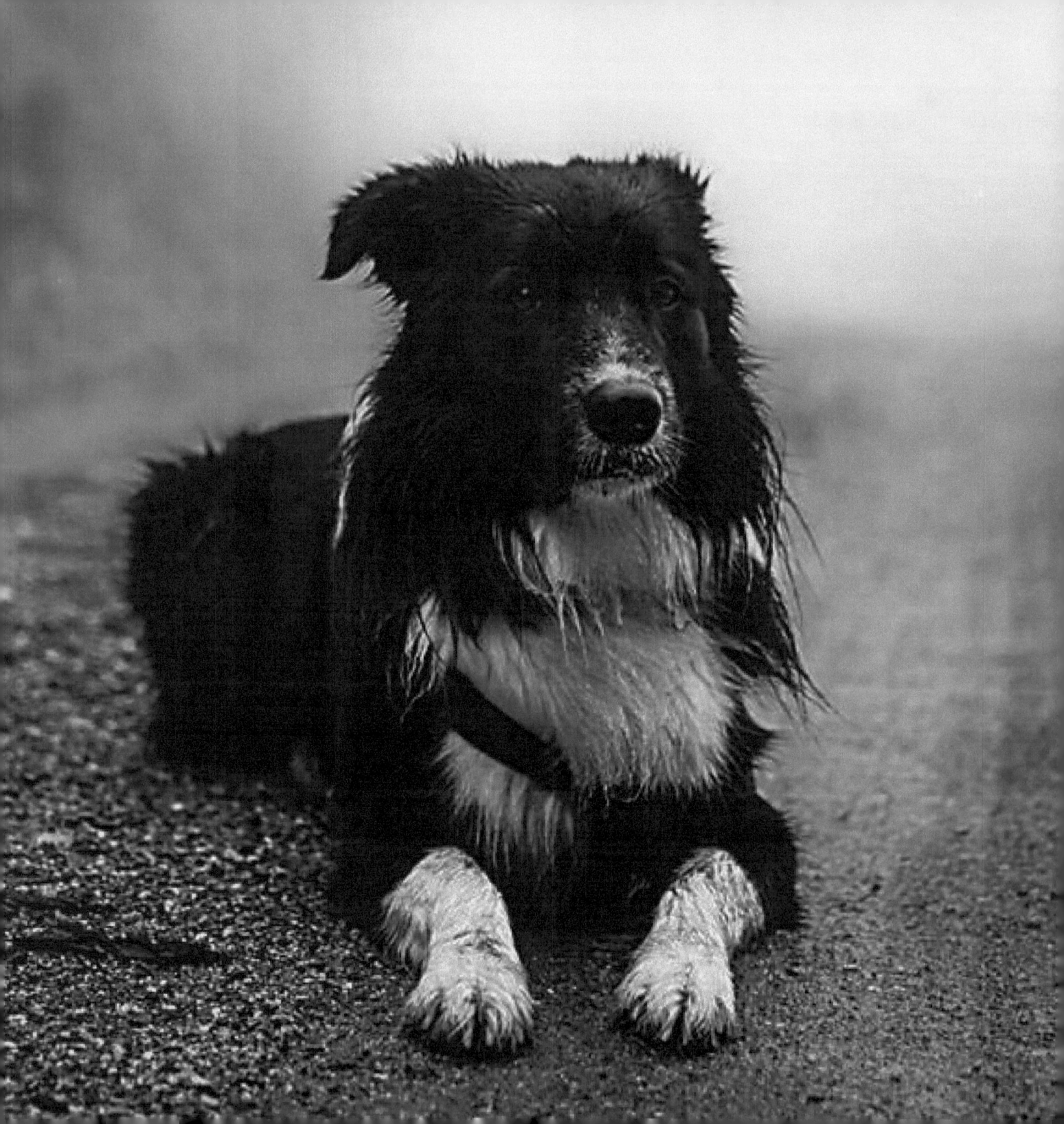

Ode to Blackie

The middle of the road was his usual spot
Arrogant little mutt
It used to be peaceful, near the Point
Across from the Hood canal cut

There weren't many lived there, he sat for hours
Waiting for master's car
Yawning and stretching, rolling in dirt
Holding court with friends from afar

As folks moved in his street cred spread
The Point was Blackie's stage
He challenged all comers, Fords and Chevies
And drivers learned of road rage

When V-eights roared around the bend
Blackie lay across the track
They honked, they cursed, they raised their fists
The mutt would never crack

Trucks and cars drove on grass verge
No-one ever won
In settling dust Blackie ambled away
Like Clint with smoking gun

cont'd over

But age caught up with little Blackie
He was running out of luck
One hot and dusty afternoon
He faced a big-arse truck

The driver sat with fearless eyes
Pumping gas and gripping wheel
Blackie sat with back to monster
His nerves were made of steel

Rubber burned as the truck took off
And Blackie somehow knew
If he didn't move his butt right then
He'd be squashed blacktop stew

He raised himself unsteadily
His head bowed in defeat
Some say he smiled and wagged his tail
As the fender mashed his seat

Now Blackie has gone to heaven
Beware when you enter there
He'll be waiting by the pearly gates
With a growl and warning stare

ANGRY SILENCE

If you were the driver of that truck
Who dared to end his reign
Beware my friend he has a plan
You'll soon be in hell again

With bared white fangs and bulging eyes
He'll never let you be
He'll stand defiant with slobbering jaw
Growling, Hey dude, remember me?

For everyone else you can fear no more
You can breathe a grateful sigh
As Blackie takes his usual spot
But lets YOU pass on by

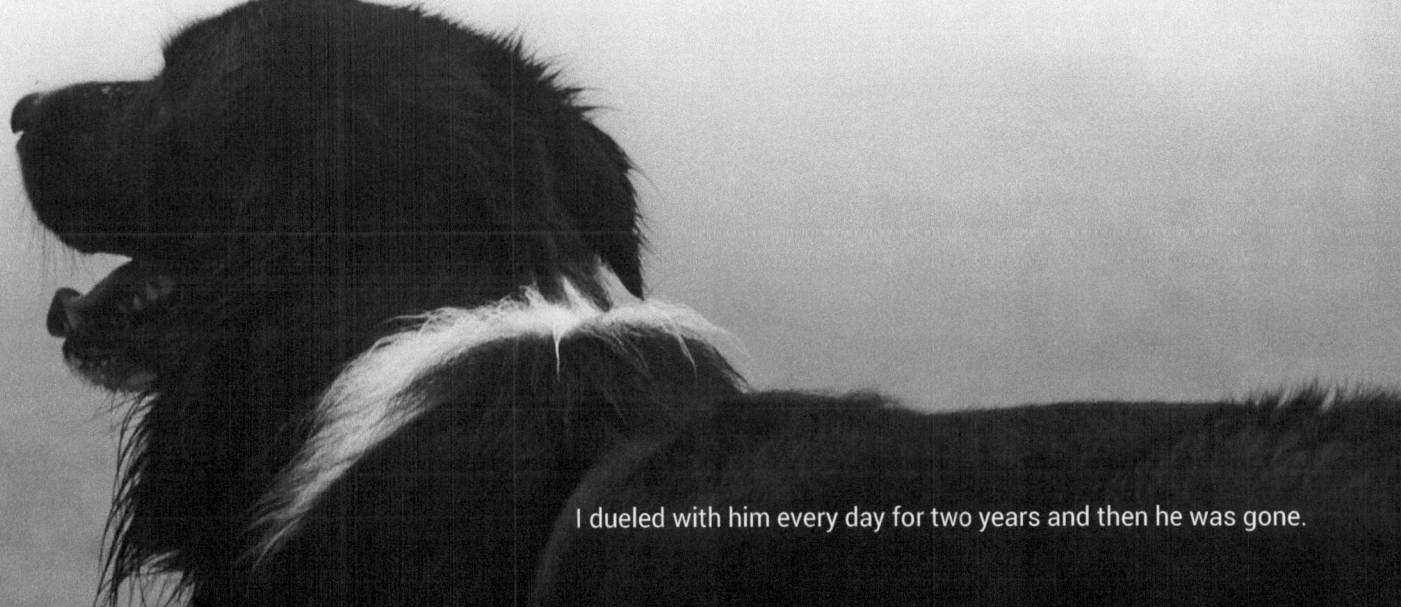

I dueled with him every day for two years and then he was gone.

News from Eire

My wife and her friend recently took a trip around Ireland in a hire car, and they had a lot of fun. From their experiences, I took the liberty of documenting their progress in a very exaggerated way. I hope you like this.

In the fair city of Dublin today, two crazy American women went on the rampage and brought the traffic system to a halt.
Said one bemused Irishman, "Sure it was a grand sight as them two ladies drove up and down the curbs like true Irish drivers. I'd have offered them a Guinness, but they looked like they already had some."

From our own correspondent in Dublin.

A general APB has been issued by the Garda today. They would like the general public to report sightings of a small car being driven by two erratic American females.

Locals have been warned not to approach. The women are said to be dangerous, especially when followed down narrow roads. The public should also be aware that when confronted by obstructions, these women have been known to use foul language.

The Garda have nicknamed them Thelma & Louise. Now State Patrol in Washington and police on Malta have been told to be on the lookout.

A representative of the Maltese authorities commented, "I do not know what all the fuss is about. Our people always drive like this.

"These ladies are most welcome here."

(An excerpt from 'Drive the crooked road to Dublin') – to be published shortly.

The two American women wanted for questioning after a spree of traffic incidents, and public disorder were finally cornered in the Connemara late this afternoon. After spending the night in a deserted lodge, the women abandoned their car after taking a wrong turn and driving along a railway track. They were traced to a hedgerow hideout and when questioned by the Garda, asked for diplomatic immunity. Said a Garda officer, "We have offered the British and Americans free Guinness for life and the use of the Connemara as a launch site for long-range missiles…but they just laughed at us."

Evening News – from our own correspondent Ilene-Dover.

Galway City Alert as 'Thelma and Louise' leg it across the country to Dunguaire Castle.

A state of panic flows across this peaceful countryside tonight as Garda search for the women nicknamed Thelma and Louise. They escaped custody while awaiting a cabinet decision from No. 10 as to where they may be sent. Guantanamo Bay is thought to be a likely place, but talks are dragging on with Washington D.C. In the meantime, all residents near Dunguaire Castle have been told there is a ten o'clock curfew, and all doors and sons should be locked up securely. The women were last seen getting into Sean Osin's car on the road to Galway. He dropped them off near the castle and sped to the nearest Garda post to report that two women had made improper suggestions to him. Sean, aged 72, was quoted as saying…"They said they'd give me anything for a bottle of Guinness, so they did. I told them to ..ck off!"

Irish Times 9/16/2013

The Connacht Hotel in Galway was tonight under siege by Garda as Thelma and Louise, the two desperate escapees from Dublin, ordered management to give them the best suite with a Jacuzzi for the night. Manager Jim O'Donnell warned authorities the girls had threatened that should they be disturbed, they would fight even if they had no clothes on. Garda Superintendent Michael Flattery said, "I have withdrawn my men to safety.

"We will wait until the morning when the women have their clothes on. There is no point in exposing good Christian men to such shameful acts of psychological torture."

Meanwhile, outside the hotel, crowds have gathered, protesting the Garda's unnecessary use of force. Some protesters carried placards with 'Let it all hang out and fight the pigs' while the others sang a chorus of 'On mother Kelly's Doorstep.' We await developments tomorrow.

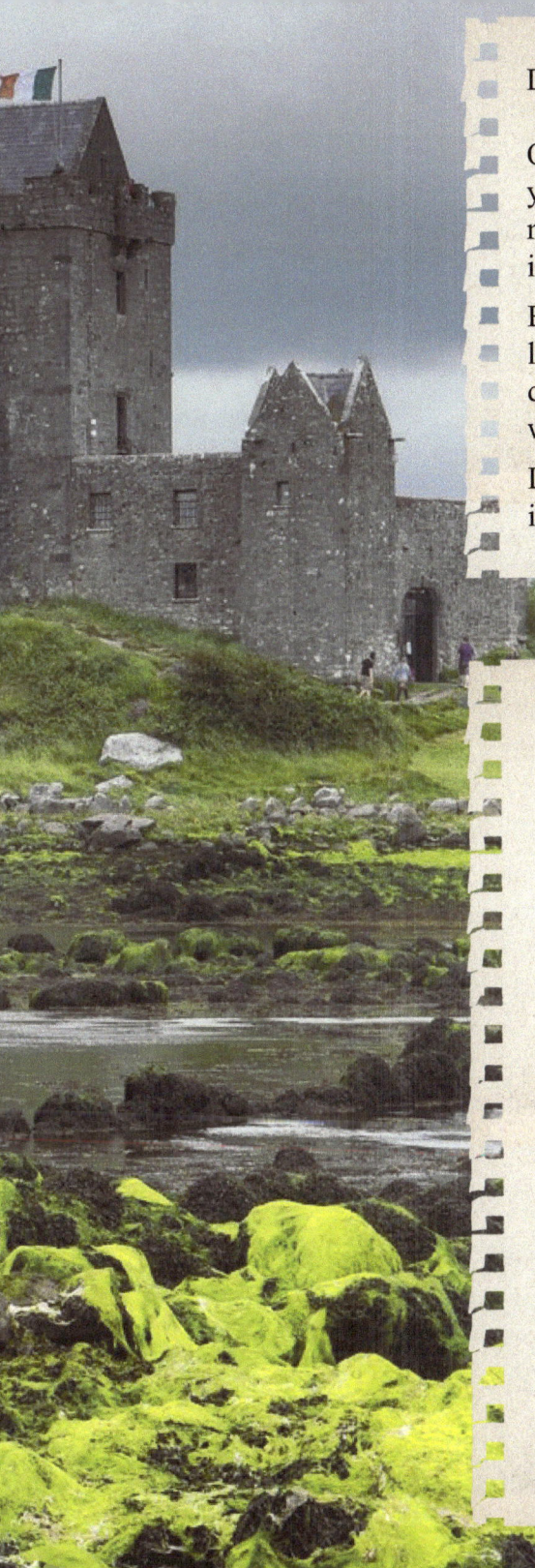

Daily Star – 23rd Sept 2013.

Off duty Irish soldiers and amazed visitors to the Waterford factory, yesterday stood speechless as the two dangerous American women nicknamed Thelma & Louise, walked past them and across the car park, carrying between them a cut glass grandmother clock worth over $200,000.

By the time the Garda arrived, the women were long gone. Thelma, who lost her nightdress in the scuffle to get away from the Connacht Hotel two days ago, was heard using bad language when she discovered the clock would not fit into the trunk of the car.

Louise was heard to remark, "I told you we should have taken the soldiers instead. They'd fit in the car and are much more fun."

Dublin Evening Express
- from our correspondent Sean O'Donnell

Flying Luggage Lands Safely

The nationwide hunt for two wanted American women dubbed Thelma and Louise is over.

Garda warned the public not to approach these women for fear of another shameful incident involving wardrobe malfunctions in front of old men.

At one point, their car mounted a roundabout and luggage slid from the rear of the hatchback. A stack of orange suitcases, large, medium, and small, landed in the middle of the road, stacked and intact. Cursing loudly, both women held up traffic while reloading and sped off with crowds cheering them on to the airport where a plane will fly them to Malta and diplomatic immunity.

The relieved Dublin Mayor Conrad O'Smits declared that any and all future American female tourists would have to be accompanied by a responsible man.

Post Report - The Irish Women's League voted to mount a placard outside their HQ, honoring the Americans for their steadfast support of women's rights. Mayor Conrad was not available to comment.

Night-time Blues

She's putting on her makeup
puttin on her lipstick too
My lady's goin to town
nails have just been polished
She's gonna find some dancing man
in some darkened motel flop
Through smoke and highland dew
smack the bed and laugh some
Gotta tell ya, I got them night-time blues

I don't know how to stop her
said I don't know how to stop her
She's the devil in disguise
always been real trouble
I can't stand all those damn lies
but I guess I'll always love her
I'm always gonna lose
I'm singin through my tears now
I got them night-time blues

Yeah, I drove into the city
Yes, I went down in the Pink Parrot
best little horn club in New Orleans
Blowin through my mouthpiece
In walks some real tight jeans
I should have left her well alone
I let her light my fuse
All that's left is emptiness
I got them night-time blues

Composer Steven Panter (UK) and I
produced five demo discs. This was one.

Midnight Train

Midnight train I've gotta get away now
yeah, I've gotta get away
cos my life's been made a misery
Twenty years of livin hell
I'm sick and tired of all them lies
There aint no more to tell
Broken man, broken soul
goin home to Maine
I'll ride that midnight train

Again, another Steven Panter - Ray Stone production

ANGRY SILENCE

Livin in tomorrow land
Oh, she's livin there today
Ev'rythin's gonna be all right
she's tellin me so
She's dreamin dreams of make believe
before she wakes I'll go
Nothing packed, just a ticket
walkin through the rain
I'll ride the midnight train

Her lovin arms around him
those lovin arms around him
Close my eyes and see them kissin
leavin me alone and blue
I've gotta get away now
yeah, I've gotta get away
cos my life's been made a misery
Twenty years of livin hell
I'm dreamin dreams of emptiness
Ride that midnight train

Guest Author
Joseph Labrum

This is a short story written by a friend who lives in and around Seattle.

It is a true reflection of the other side of city life, both sad and all too often a sign of the times we live in.

It is a remarkable piece. Joe Labrum wrote it in the first year he decided he wanted to be a writer.

While having no previous experience of this art form, he managed to inject much feeling and sympathy for the main character.

Today he continues to write short stories, and hopefully a novel soon.

This work is author edited.

cont'd over

Seattle Christmas
Joseph Labrum

The gaiety of the season was in the air. Scott saw it in the faces of people waiting their turn. The sound of a steel drum band playing a reggae version of "Noel" filled the square. The line at the window curled around Westlake plaza twenty deep. He envied them and cursed having to fight his way through the mass. He needed coffee and begged a stranger for a handout.

"Sir, I need two dollars to get home. Can you help me?"

Success. He joined the Starbuck's line. He longed for a warm cup to wrap his hands around. The straps of his backpack dug into his shoulders, and his feet were numb. But right now he thought more about that coffee than where he would sleep tonight. The line moved along, and finally, he wrapped his hands around the heat of his cup. He welcomed the warmth through his fingerless cotton gloves, and it felt like heaven.

The size of the crowd diminished as the last minute shoppers headed home with their packages. He tossed the empty cup in the trash and headed down Pike street. A group came his way laughing, walking four abreast, forcing Scott into the street to get by.

He tried to avoid contact by watching everyone's movements, but he seemed invisible. The dinner club set is out early, Scott said to himself, probably because of Christmas Eve. He felt himself knocked off balance and fell against a middle-aged man in an expensive-looking gray overcoat.

"Watch where you're going, you drunkard," the man yelled, and pushed Scott back the other way. The weight of his backpack toppled him, and he fell on his back, laying there

like a turtle. The crowd parted. Scott had just enough space to struggle up. At last, he was at First Avenue and could take refuge in the market.

There were still a few shoppers though half the vendors had gone. Scott hurried past the brass pig at the entrance and around the fishmonger's stall. He turned and skipped down the stairs two at a time to the lower level. At the bottom, he turned left into the large men's room and opened his backpack on the long vanity in front of one of the mirrors.

After rummaging for the few toiletries he had, he pulled out the closest thing he owned to a clean shirt. He wasted no time as he took off the sweatshirt he had slept in for two nights and sponged off his face and upper body. He tried to shake the wrinkles out of his shirt and put it on. He ran a brush through his hair and wished he had something to shave with. One last look and he was off.

The Mission down First Avenue in Pioneer Square offered his first opportunity for a holiday meal since he lost his job and the unemployment benefit ran out. Scott walked in and saw the kitchen a hive of activity. People were busy everywhere carving meat, mashing potatoes, chopping vegetables, preparing a feast for a king. Scott found a chair near the entrance and sat by himself.

A long oak table was set in the middle of the hall. Scott joined in as everyone gathered around a tree to sing carols. Then the host invited everyone to the table. Scott lost his balance when an enormous man in a red plaid flannel shirt and overalls shoved him and plopped into the chair Scott had just pulled out for himself.

"Excuse me." Scott's sarcasm was unmistakable though his voice shaky. "There are plenty of seats."

It would be suicide to challenge the giant, so Scott found another place and moved in.

"I want to thank the Lord for His generosity," came from the host.

Yea right, thought Scott. Finally, an "Amen" followed by the command to dig in.

Scott sat alone sipping coffee and fighting sleep. Months of living on the street had reduced his stomach to the size of a walnut, and now he suffered. "Can I just stay in this chair for the night," he asked a volunteer seated next to him.

"I'm afraid not, sorry," said the volunteer.

He also knew no bed was available, he had asked.

Soon the clock struck midnight. The party and Christmas Eve were over. Scott greeted Christmas morning carrying his backpack and sleeping bag, in search of a doorway to shelter him from the drifting snow.

Ray Stone: Author

Contact Ray here:
Website: RayStoneAuthor.org
Email: ray@raystoneauthor.com

Twitter: @raystoneauthor?lang=en

Facebook: http://facebook.com/raystoneauthor

Pinterest: http://pinterest.com/
https://www.pinterest.com/raystone/boards/

Tumblr:
https://www.tumblr.com/blog/raystoneme

Linkedin:
http://linkedin.com/in/ray-stone-a4ab3355

Shutterstock:
http://shutterstock.com/g/raymondstone1946

All Ray's books are available on Amazon.com

Ray's Author Page:

https://amazon.com/Ray-Stone/e/B005EZL4Y2/

Poetry

ANGRY SILENCE

LIFE OVER A CUP OF TEA

Fiction

CRATE OF LIES

TROJAN TOWERS

ISIA'S SECRET

TWISTED WIRE

LITTLE GEMS

Ray Stone is an accomplished author with a variety of published works to his name. Born just outside London in 1946, he grew up in post war Britain during a period of depression and ration books, bombed out housing and BBC radio. At school he won a writing competition at the age of eleven and later in his teens went on to widen his interest in the arts.

At the age of eighteen he began writing poetry and lyrics whilst studying at college. Two years later Ray worked in theatre as a technician with many orchestras and artists including the London Philharmonic, London Symphony, Mantovani, The original Doyle Carte Opera Company, Harlequin Ballet, Joan Baez, Jimmy Hendrix, Oscar Peterson and worked on local shows such as My Fair Lady, Camelot and West Side Story.

His poetry won him first place in 1998 in an international internet poetry competition with 'Angry Silence.' Moving to Colchester in the same year he wrote a full page article about the historical significance of the locale and was published with a by-line in the local press. Whilst writing his first novel Ray returned to writing lyrics and teamed up with a local composer. Together they produced and recorded five blues numbers.

A book of poetry and lyrics, *Life over a cup of Tea,* was published in 2011. Ray's first novel, *The Trojan Towers,* was published in 2005. A second political thriller, the first of the Enda Osin Mysteries, *Isia's Secret,* was published in September 2013. The next in the series, *Twisted Wire,* followed in September 2014. In 2015, Ray published a sequel to *The Trojan Towers,* a chase thriller titled *Crate of Lies.*

All of his works are available in print, ebook versions, and shortly on audio too.

Ray now lives on Cyprus and continues to write every day. He is also a professional photographer. His latest work is a book of short stories - Little Gems. He is currently working on a third ENDA OSIN mystery novel. He loves readers to leave a review.

www.ingramcontent.com/pod-product-compliance
Lightning Source LLC
Chambersburg PA
CBHW051045180526
45172CB00002B/532